UNICORNS ARE JERKS
a coloring book exposing
the cold, hard, sparkly truth

drawn and written by
Theo Nicole Lorenz

ISBN 978-1492647201

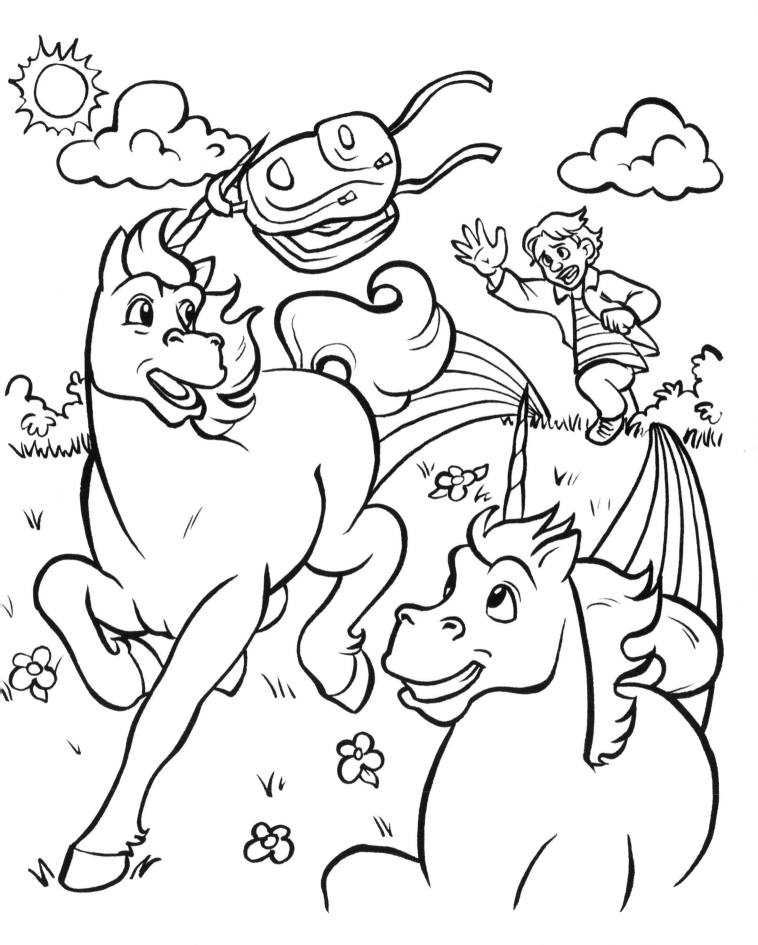

Everyone thinks unicorns are pure and magical,
but really they're jerks.

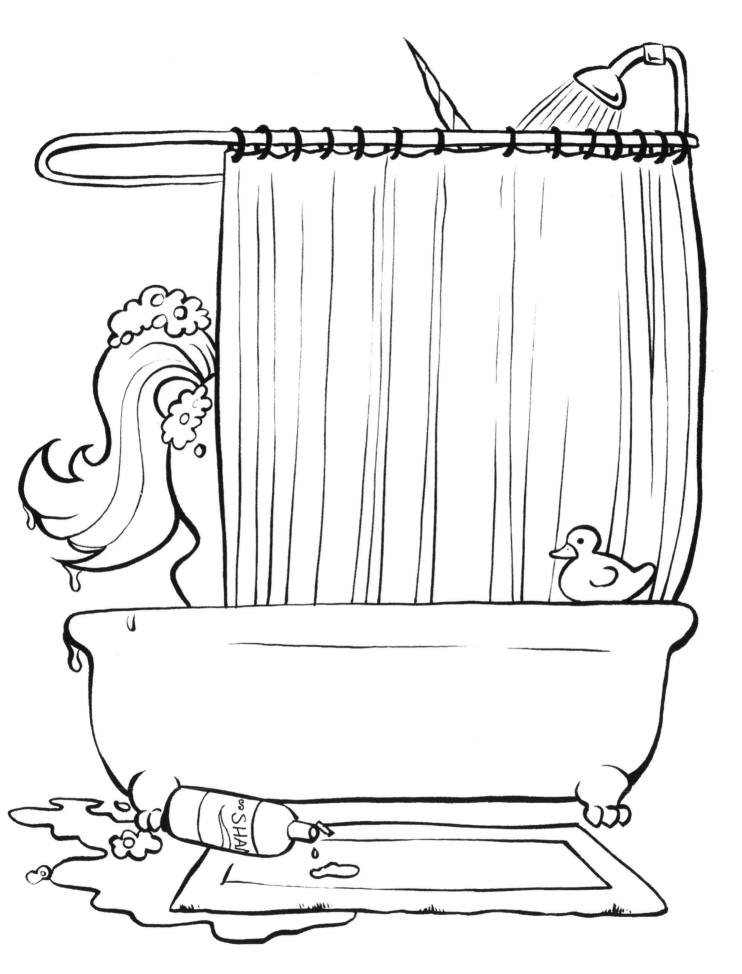

Unicorns use up all of your shampoo.

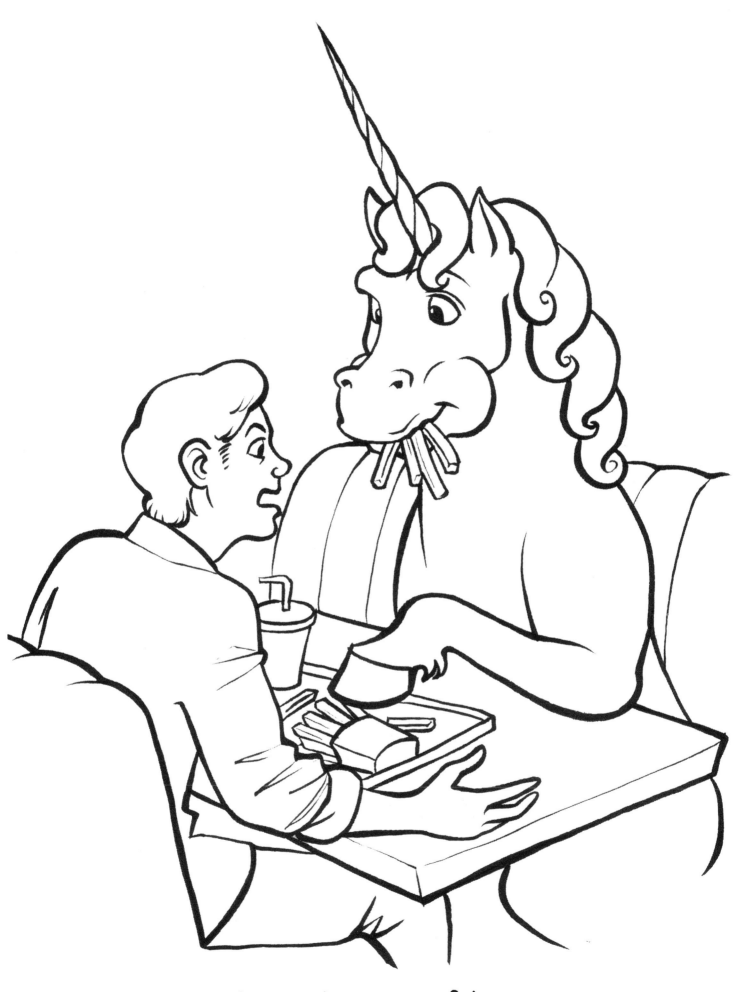

Unicorns hog your fries.

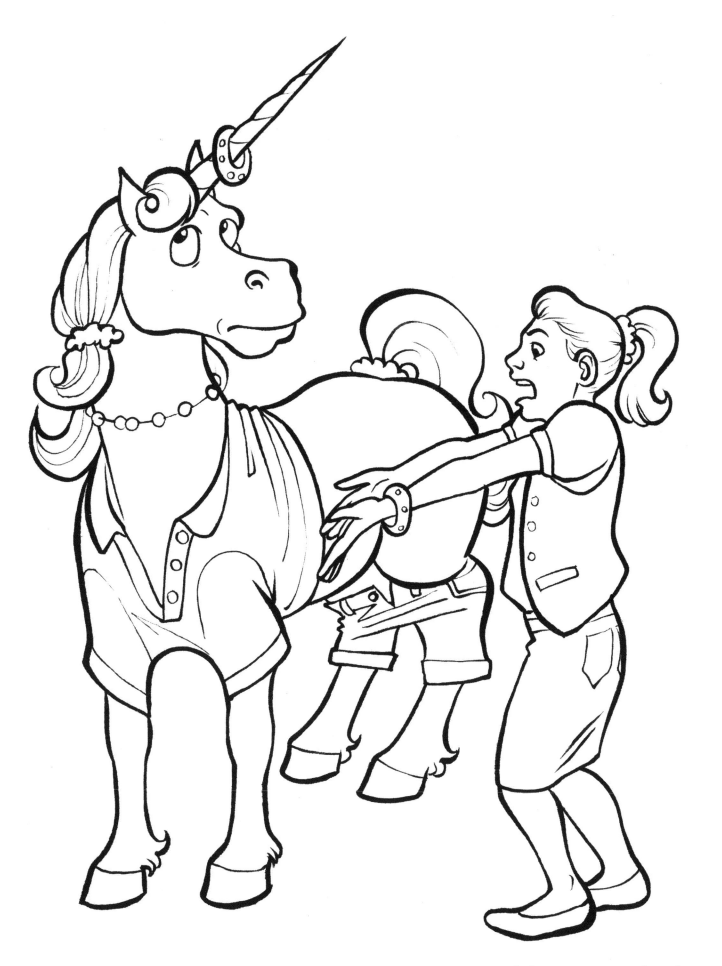

Unicorns borrow your clothes without asking permission and stretch them out.

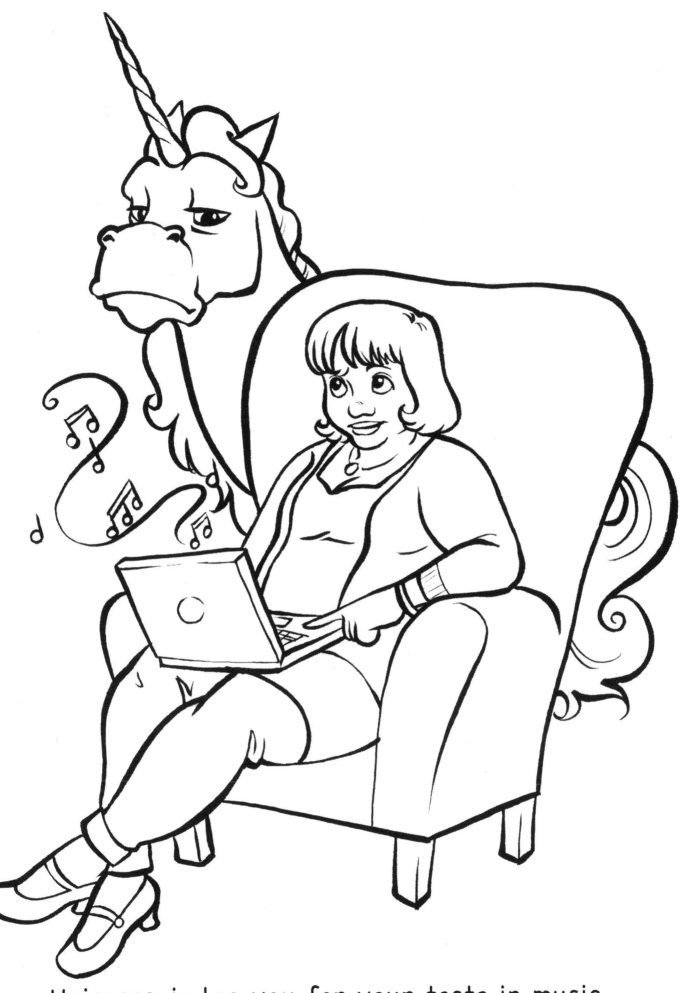

Unicorns judge you for your taste in music.

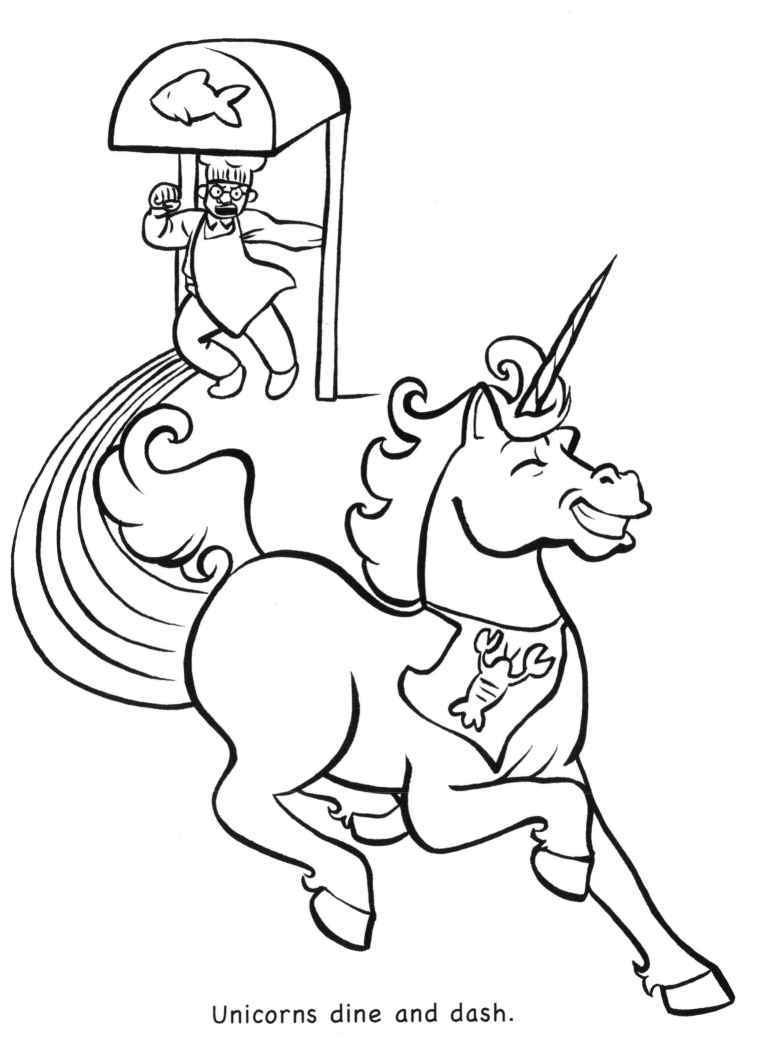

Unicorns dine and dash.

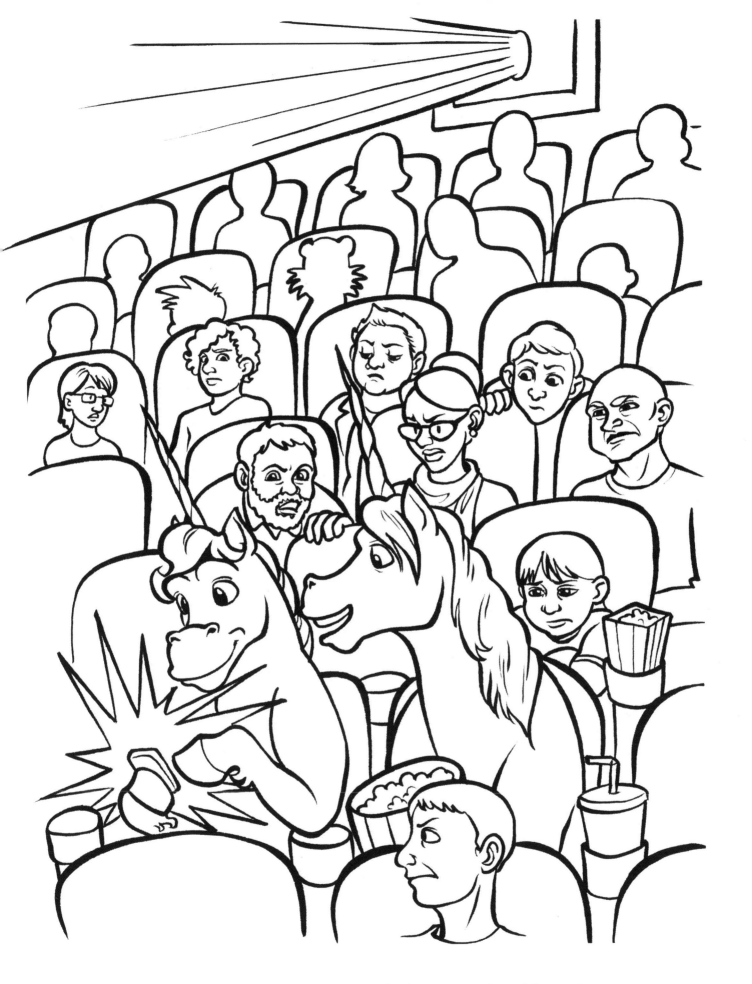

Unicorns talk and text in movie theaters.

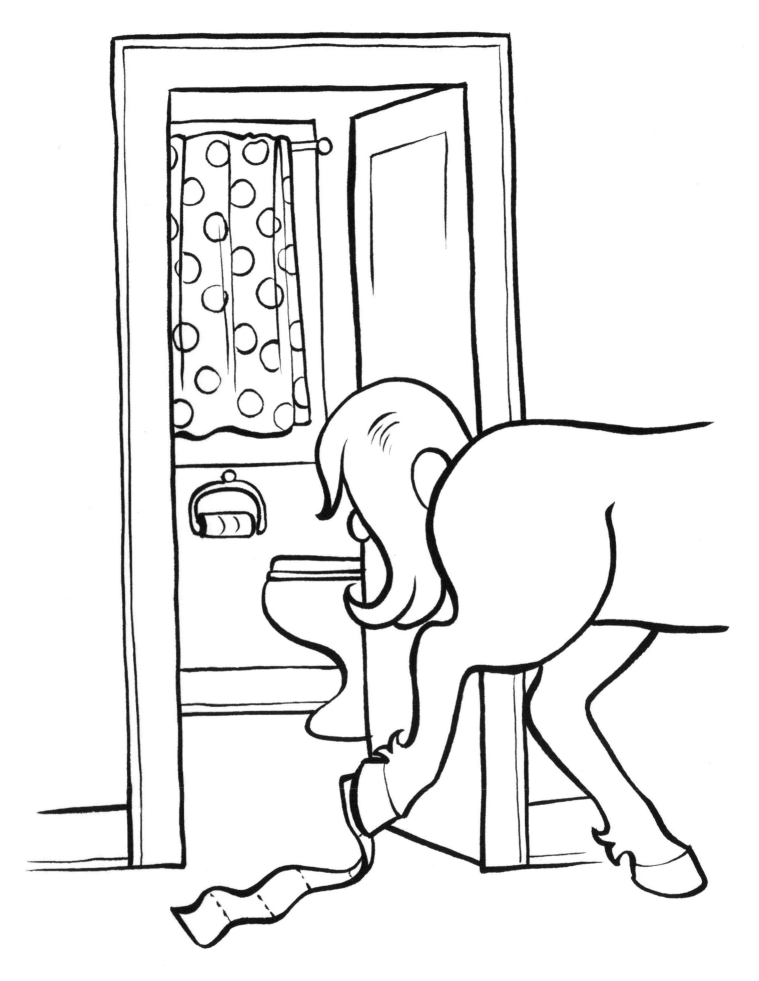

Unicorns don't replace the toilet paper roll.

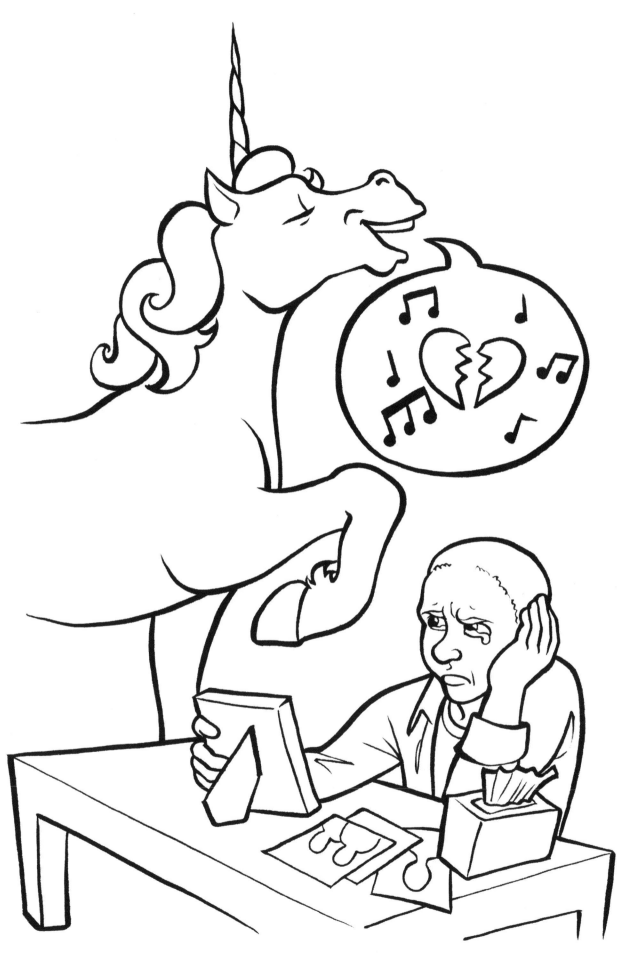

Unicorns sing breakup songs around you
when you've just been dumped.

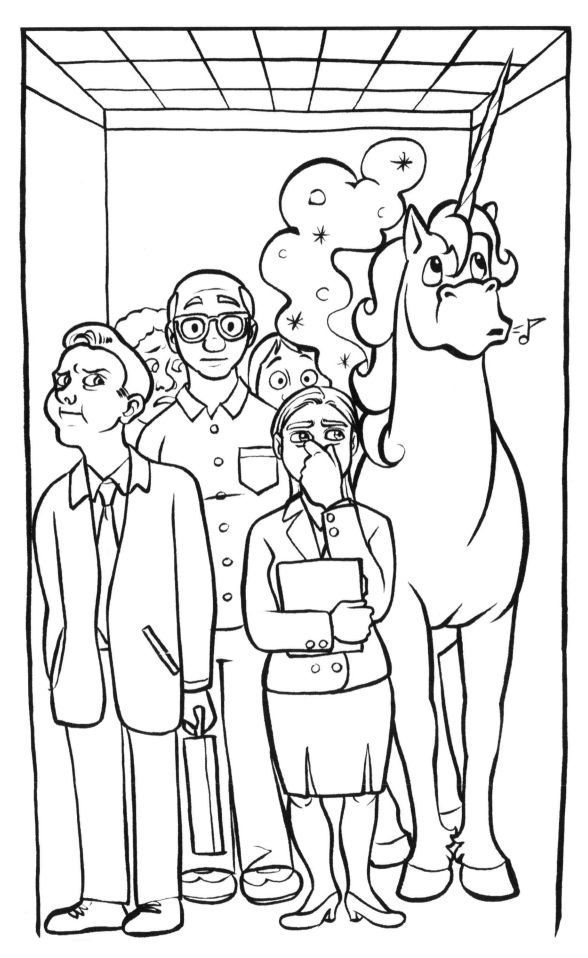

Unicorns fart in elevators.
On purpose.

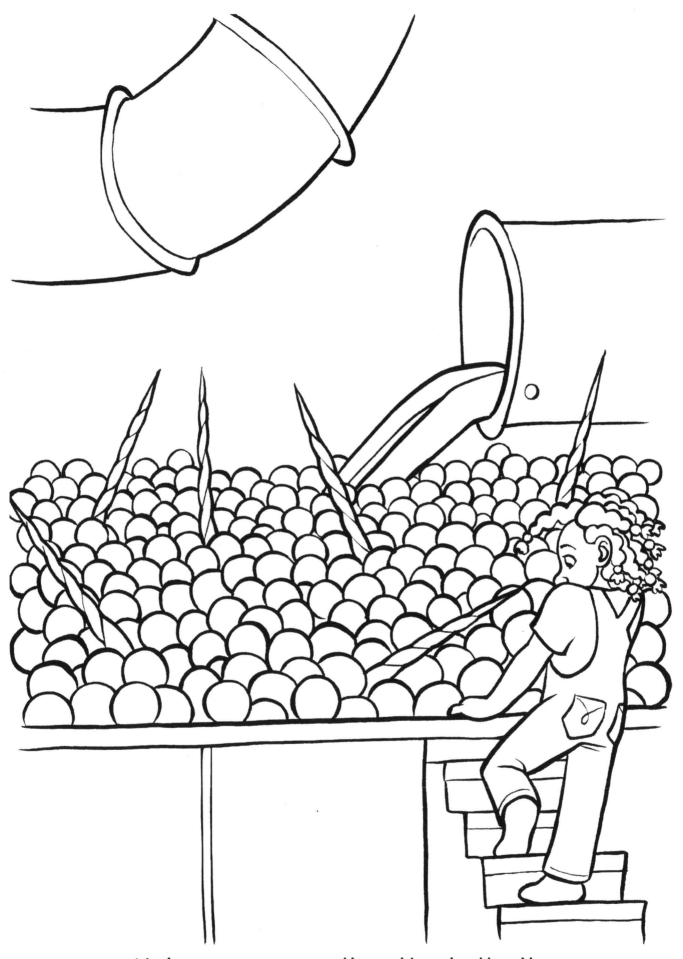

Unicorns monopolize the ball pit
and don't let anyone else in.

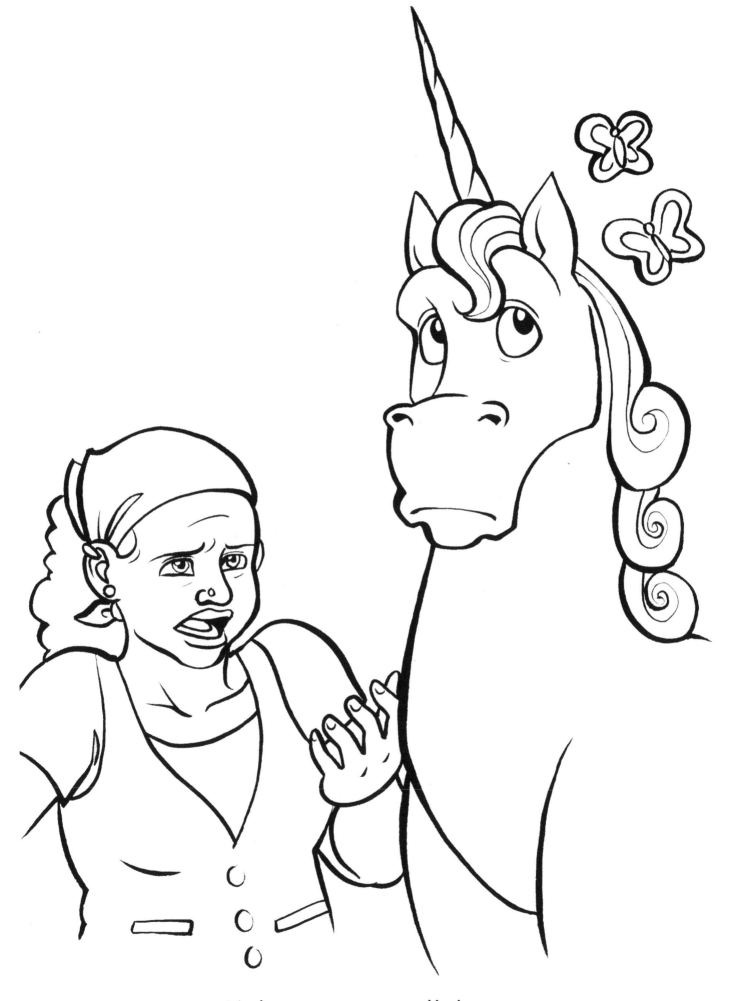

Unicorns never listen.

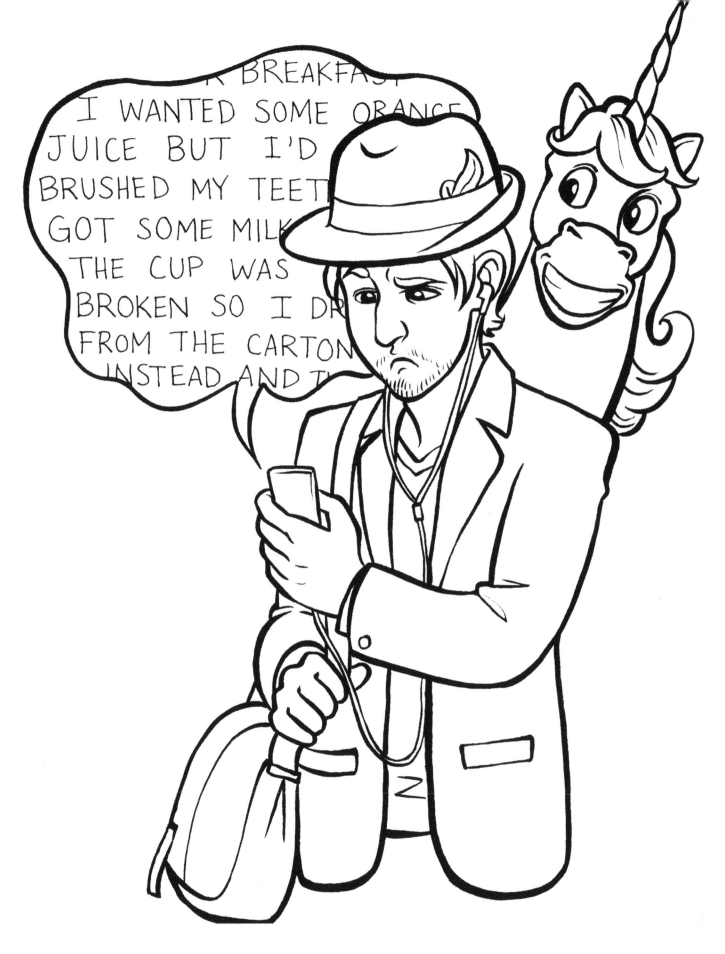

Unicorns delete your music collection
and replace it with their own audio memoirs.

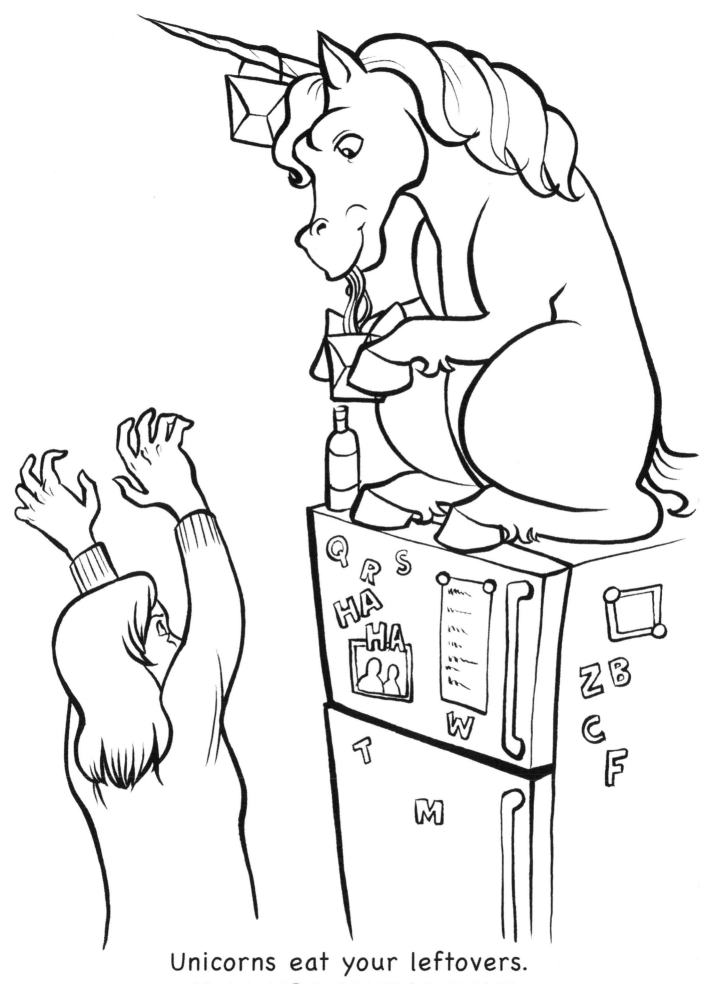

Unicorns eat your leftovers.
YOU WERE SAVING THAT!

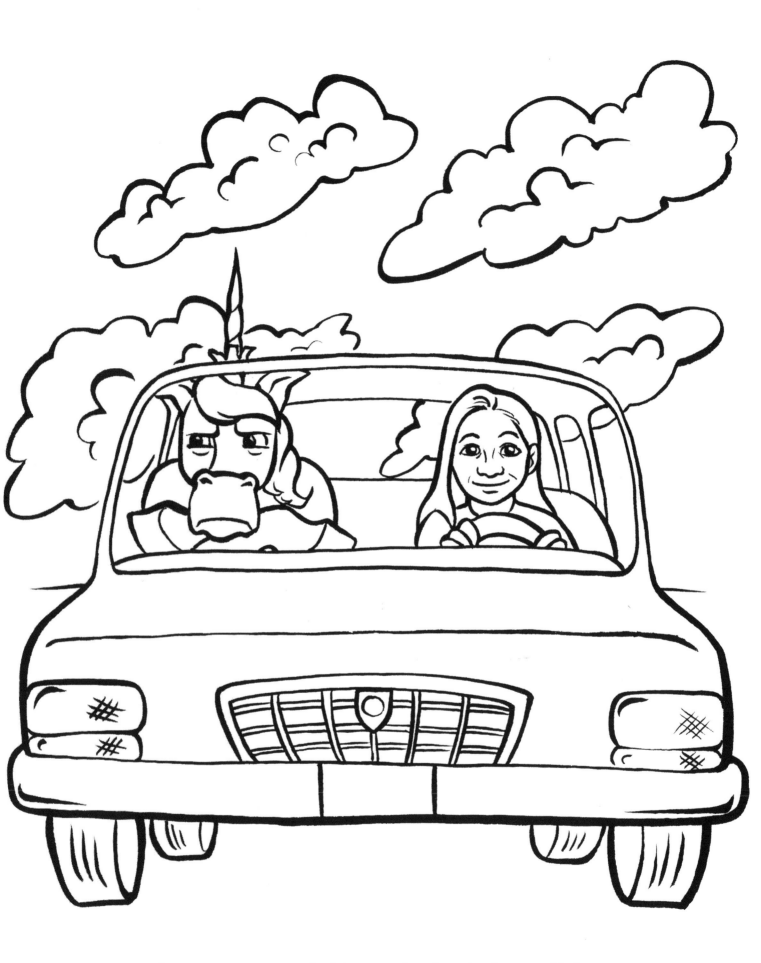

Unicorns spend the whole trip sulking
because you wouldn't let them drive.

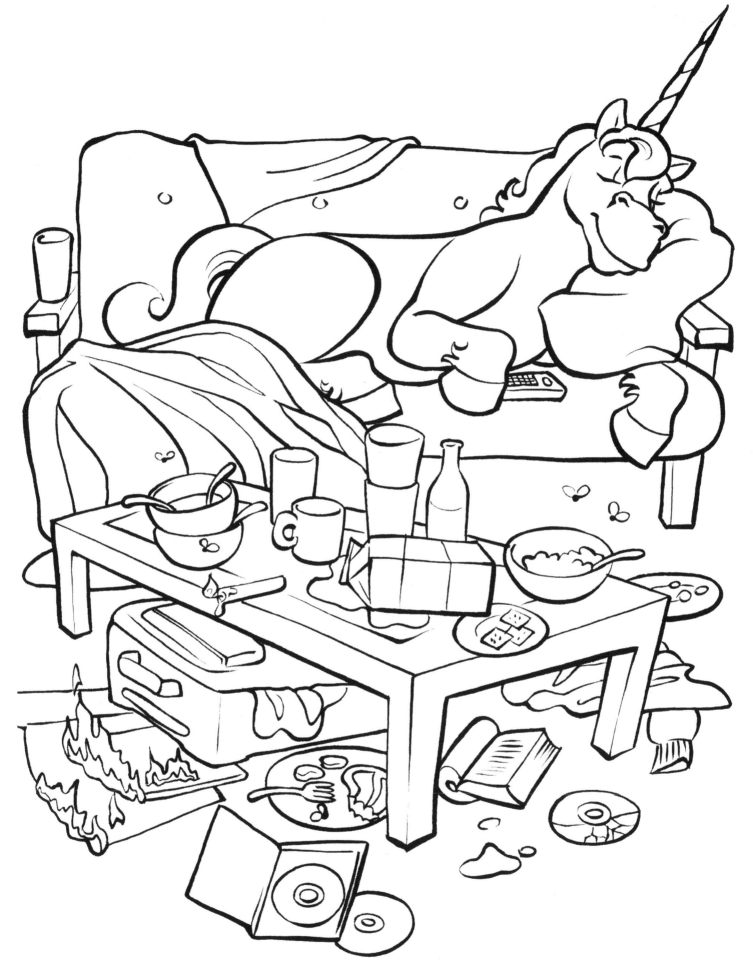

Unicorns are the worst house guests,
and they never leave.

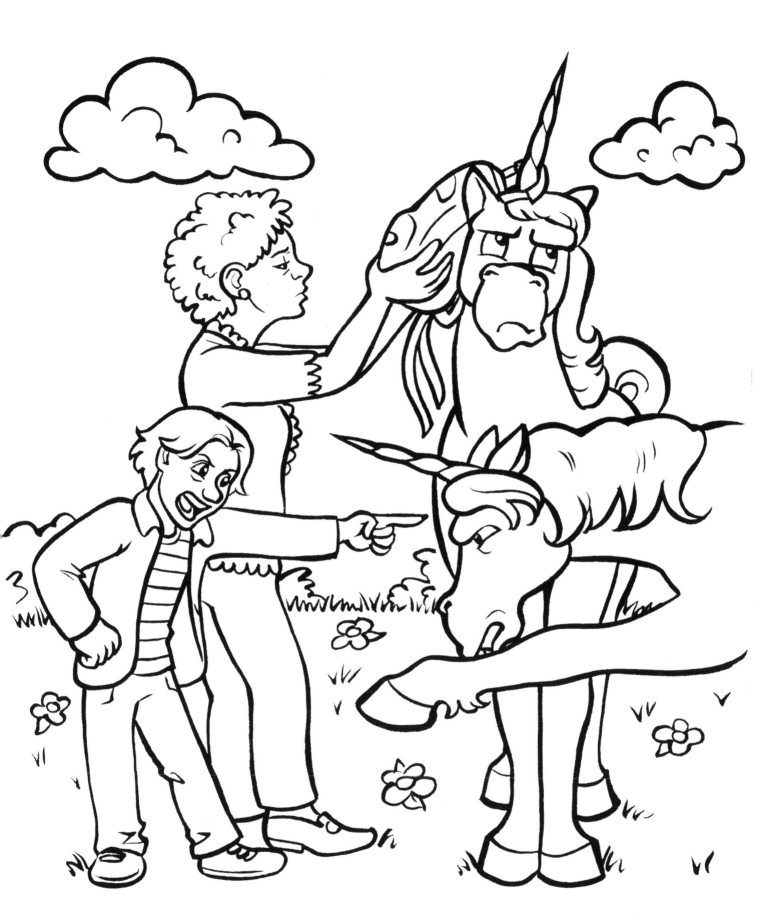

When you point out that unicorns are being jerks,
they act like YOU'RE the jerk.

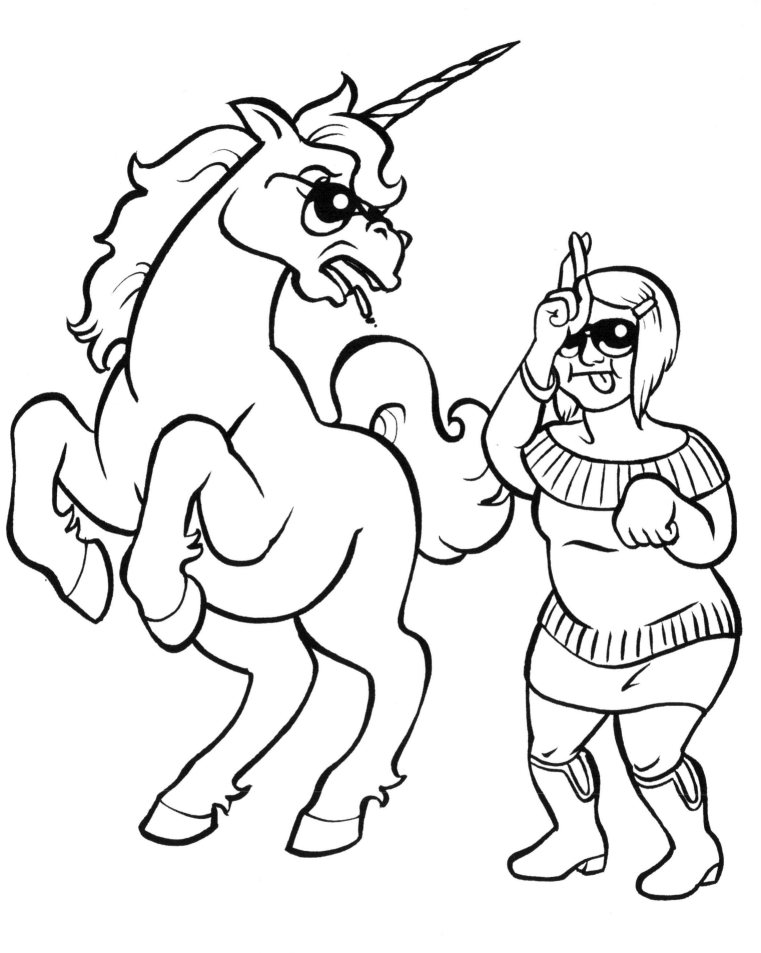

Don't be a unicorn.
Even unicorns don't appreciate it.

About the Artist

Theo is an artist, fantasy writer, and aspiring coloring book tycoon. She lives in Saint Paul, Minnesota with an abundance of toy unicorns (most of whom are okay, even if they can get kind of judgmental).

Unicorns Are Jerks is her second coloring book. The first, Fat Ladies in Spaaaaace, is available wherever body-positive sci-fi coloring books are sold (mostly Amazon.com).

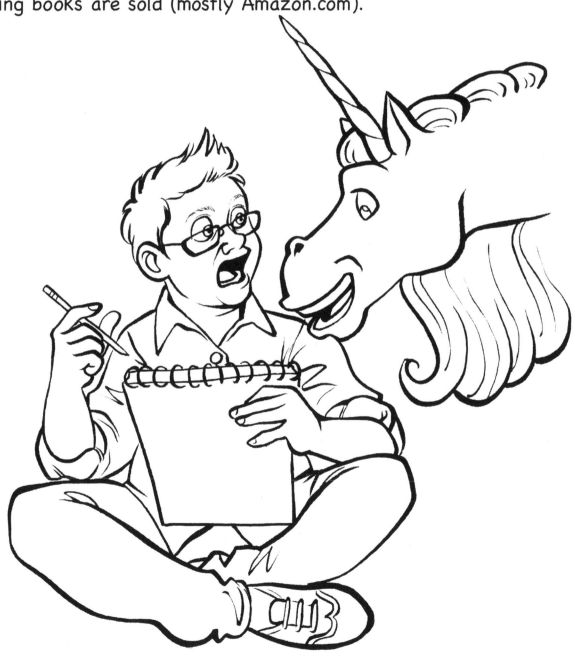

Made in the USA
Middletown, DE
15 June 2018